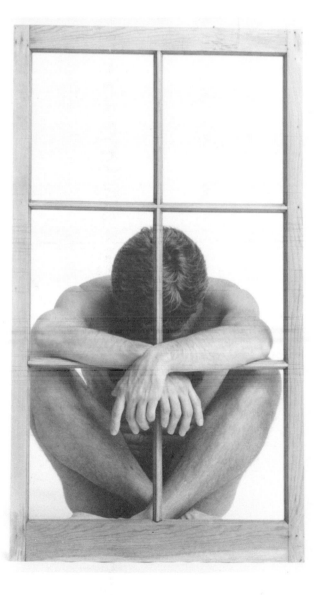

photographs by Richard Plowright

Boston: Alyson Publications, Inc.

Published as a trade paperback original by Alyson Publications, 40 Plympton St., Boston, Mass. 02118.
Distributed in the U.K. by GMP Publishers, P.O. Box 247, London, N17, 9QR, England.

First edition, first printing: September 1990.

ISBN 1-55583-160-5

The models used in this book were:
Marc Anchart; John Bannerman; Morris Breslin; Ronnie Brunaccioni; Peter Curl; Lewis Diamond;
Peter Dublin; Chuck Flanders; Albert Forster; Eric Grace; Loran Hardcastle; Bill Haworth; Mike Hickey;
Rupert Headley; Sid Kemp; Peter King; Paul Lamonde; Craig Lawrence; Rene Leduc; Edward LeMay;
Mel Lichtenberg; David Alan Love; David MacGillivay; Peter Maloney; Tom Marshal; Charles Mixon;
George Mousseau; Jorden Myers; Aeron Nicols; Michael Podadecki; Paul Rutherford; Jim Saar; Wes Sorgaard;
Leo Scomparin; Tom Stewart; and Murray Tarleton.

INTRODUCTION

As the art of photography passes its 150th anniversary, the subject of the nude is still controversial in some quarters. The past decade has seen many new obscenity laws passed, and challenged, as would-be censors and artists clash over freedom of expression.

During the years that I was creating the images for this book, my photography was repeatedly turned down for publication because I used the term "male nude." I found that the phrase "creative male studies" was more likely to get results. Frontal nudity has long been acceptable for female subjects, but there is a stigma about depicting the male form. Even male nudes showing the buttocks, but with no frontal nudity, are often frowned upon.

I have chosen black-and-white photographs for this book. I prefer to work in the monochromatic range, with its dark and light shades gradually dispersing into greys. This allows the eye to focus on the aesthetic qualities of the work, without the support — or distraction — of vivid colors.

The use of backgrounds is also important. I prefer black seamless paper, for it has strength and drama, though white certainly has its place. Most of my work is done inside my studio, because it is a comfortable place to work. It is small and simply equipped, but serves its purpose well.

I use simple lighting: a 40-watt or 60-watt bulb overhead, with several silver reflectors. On occasion I used an old curved television screen, and achieved special effects by bouncing light onto its silver surface. I also used two 283 Vivitar flashes with white umbrellas for additional lighting.

Generally I used Kodak 400 ASA film, which is then pushed in developing. When using dramatic and limited lighting, a fast film is necessary to capture the image without any movement. This can occasionally create grain, giving a special effect to some of the images.

For cameras, I have a 2-1/4 Kowa with 150-mm and 85-mm lenses. I also use a 35-mm Olympus with various lenses. A tripod is essential for my style of photography.

Working with models can be quite easy if you establish your goals at the beginning. Usually I know exactly what I'm after; I select the prop first, then the model. In the photo "Fan Male," the extension of the arms had to be exactly right to grip each side of the fan. I considered several models before finding the right one. Sometimes, however, the process is reversed. I encourage models to handle the props, and they often provide fresh ideas for new images that I may not have previously considered.

My style of photography does not emphasize the face. If the face is shown, it is seldom directed toward the camera. Instead, it is hidden by shadows or props. This brings a mystery into play: an emotion, or a sense of power within the image. The eyes can suggest too much. I attempt to bring an anonymous quality into the final print. Rather than trying to blatantly provoke a desire, I prefer a subtle approach. Observers will find some of their own emotions reflected in each image.

I have a term to describe this combination of technique and image, and the satisfaction of seeing the models and props in harmony. I call it "creative adrenalin." What a great feeling it is, when it occurs! Happily, it occurred many times during the creation of these images. I hope the resulting book will give you an understanding of this "creative adrenalin."

Enjoy!

Richard Plowright

ACKNOWLEDGEMENTS

Many people have helped me in my career in general, and in preparing this book. I especially want to thank my parents, who probably never knew how a gift of a Baldesa camera would change my life.

Wes Sorgaard's support, friendship, and encouragement kept me going when my heart wasn't there. Thank you, Wes.

I'm most grateful to Maryon Kantaroff for her beautiful sculpture "Tristan and Iseult". I also want to express my gratitude to Maia-Mari Sutnik, photographic co-ordinator of The Art Gallery of Ontario for her hospitality and honesty in viewing my images; my attorneys, Marlene A. Maletz (Boston) and Peter Maloney (Toronto); Irene O'Meara for writing about my photography for *Photo Life;* and The Robert Saxe Gallery for exhibiting my work so early in my career.

I want to thank all the models who posed for me, many of whom were amateurs. Without them, none of these images would exist. Some models started as friends or neighbors; others became friends as we worked together. My work with the Ontario Bodybuilding Association gives me a great opportunity to find a more muscular model when needed. I am grateful to all who have helped, especially those in photos that were not selected for this book. There will be other books soon, I'm sure.

Others whose help and support I appreciate are my friends on Palmerston Blvd.; Canadian Airlines; and most of all, the staff at Catnaps Guesthouse, especially Tetley & L.C., who allow my work to decorate their walls.

Finally, my thanks to Sam, my eighteen-year-old cat who always agreed with me when decisions had to be made.

To you all, I say thank you, many times over.

This book is dedicated to the memory of:

Dr. Jerome Delaurier

Rene Leduc

Murray Tarlton

Paul Trevorrow

Jim Saar

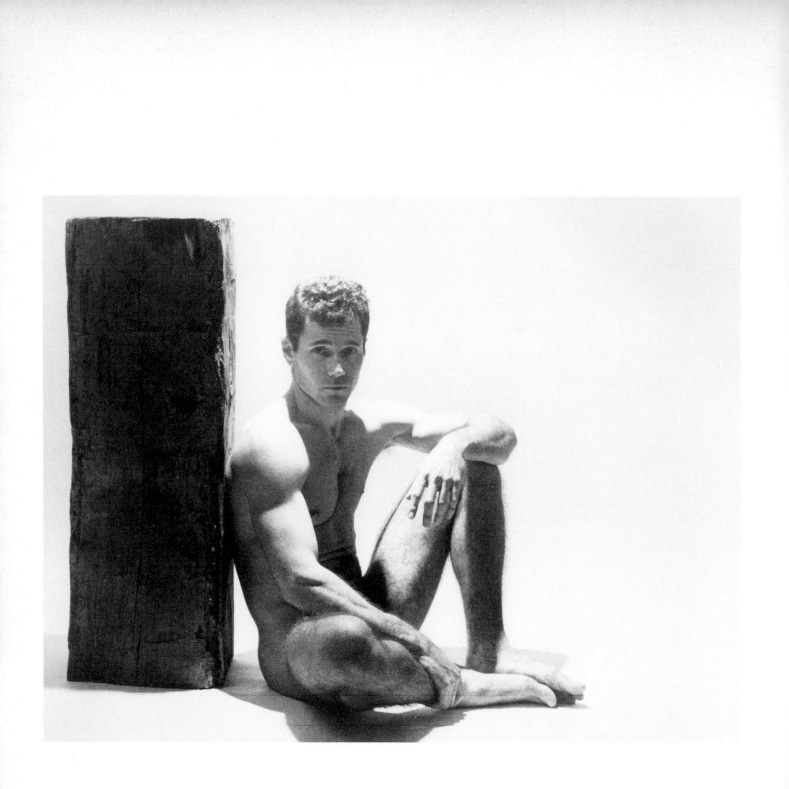

■ himage #10　　　　　　　　■ right: himage #23

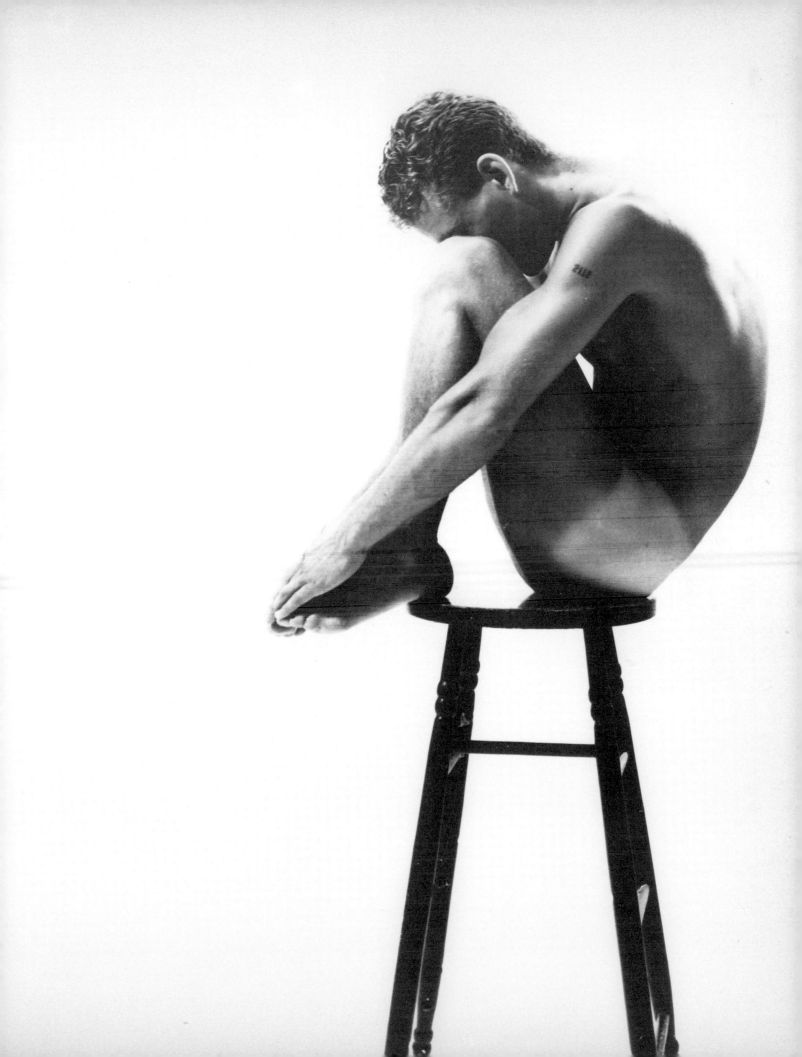

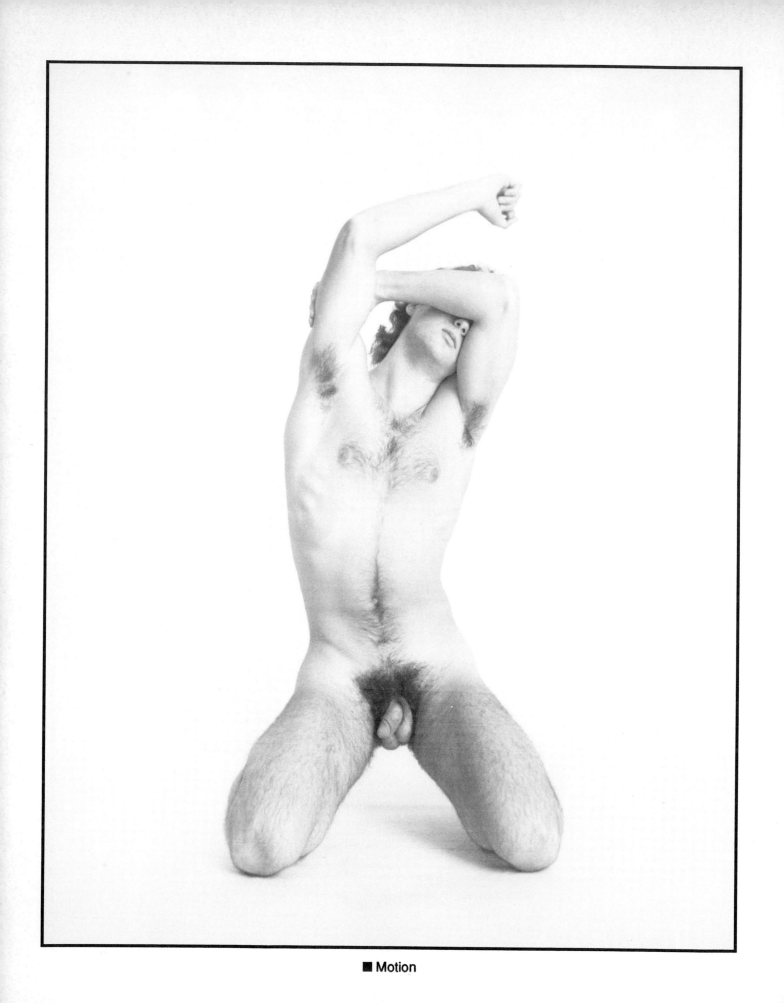

■ Motion

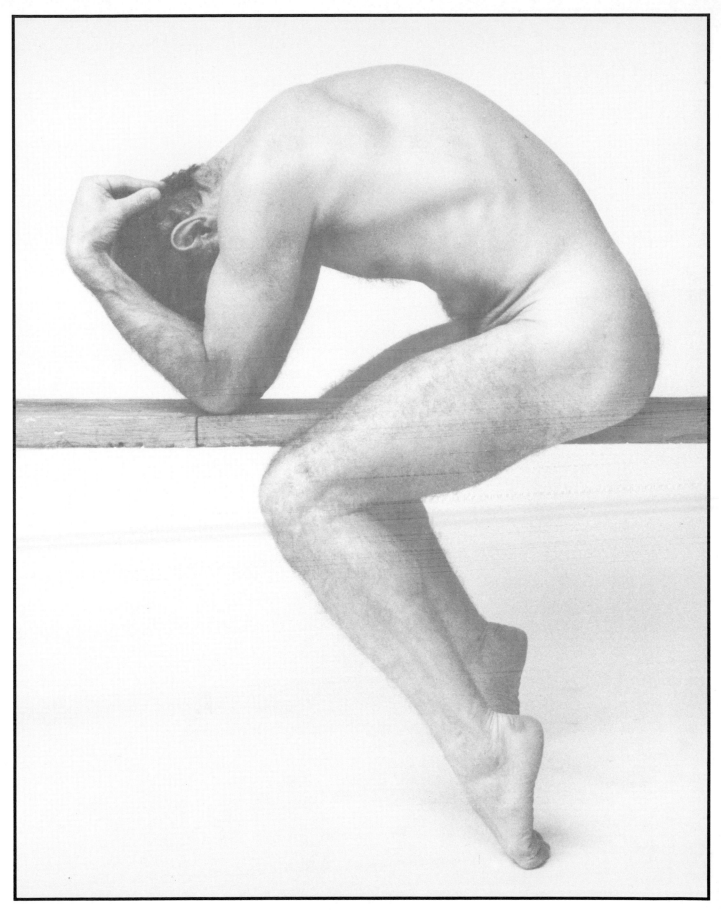

■ himage #11

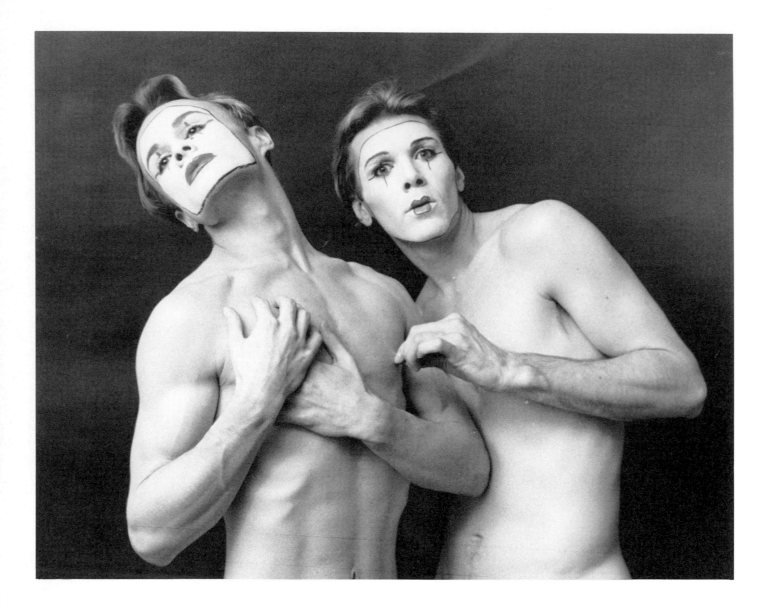

■ Jeux

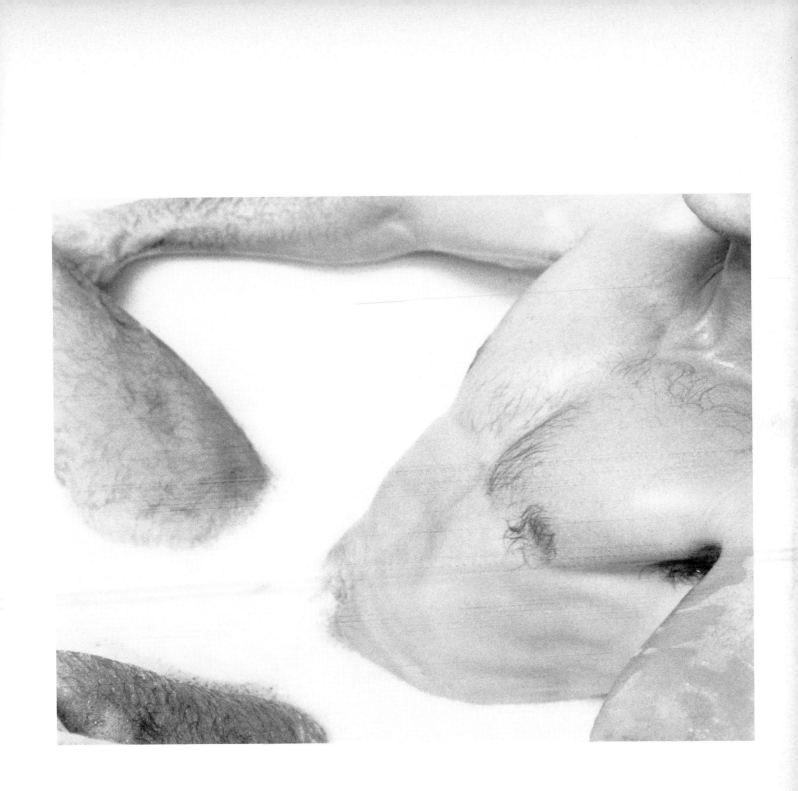

■ Aqua

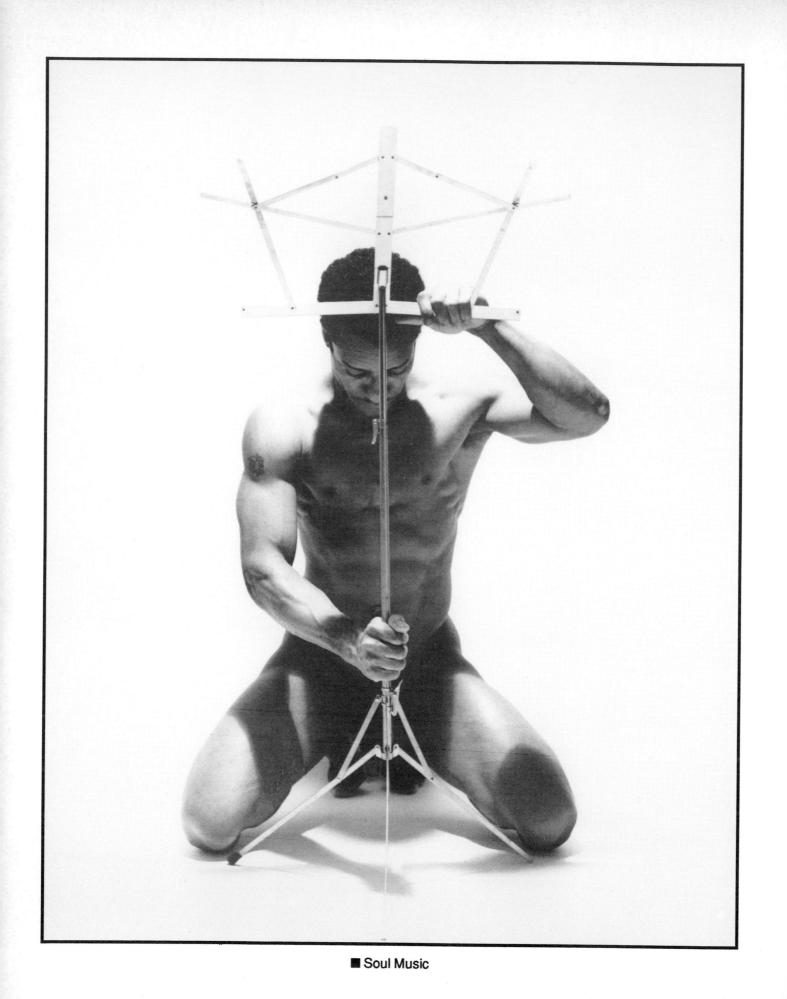

■ Soul Music

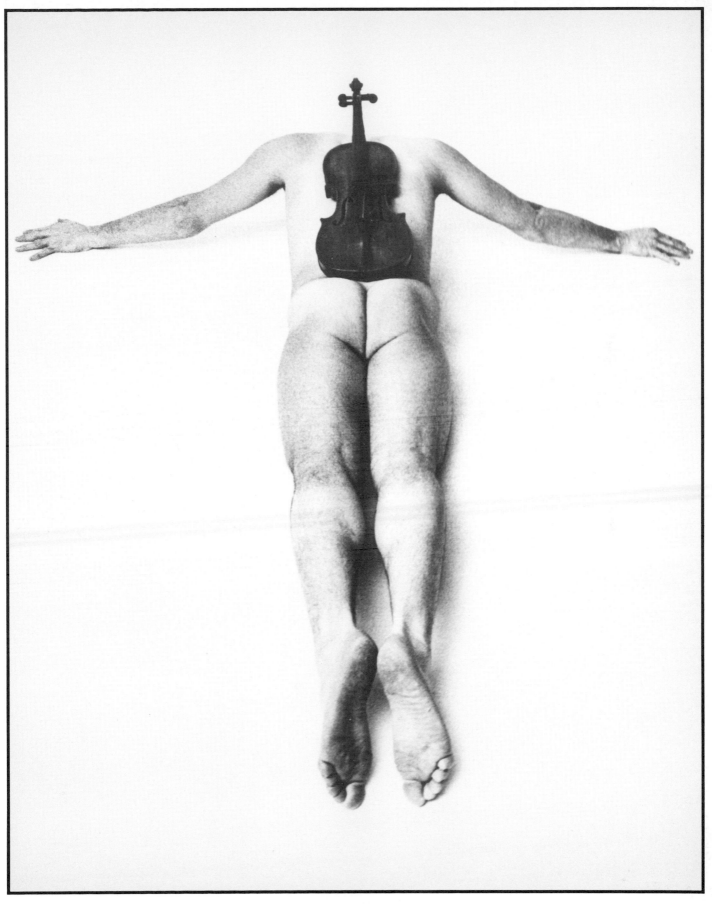

■ The Soloist

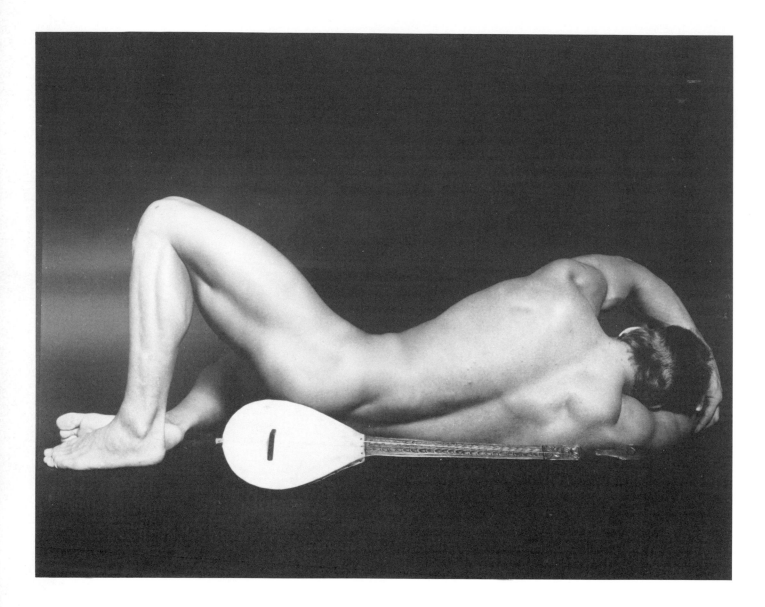

■ Sonata

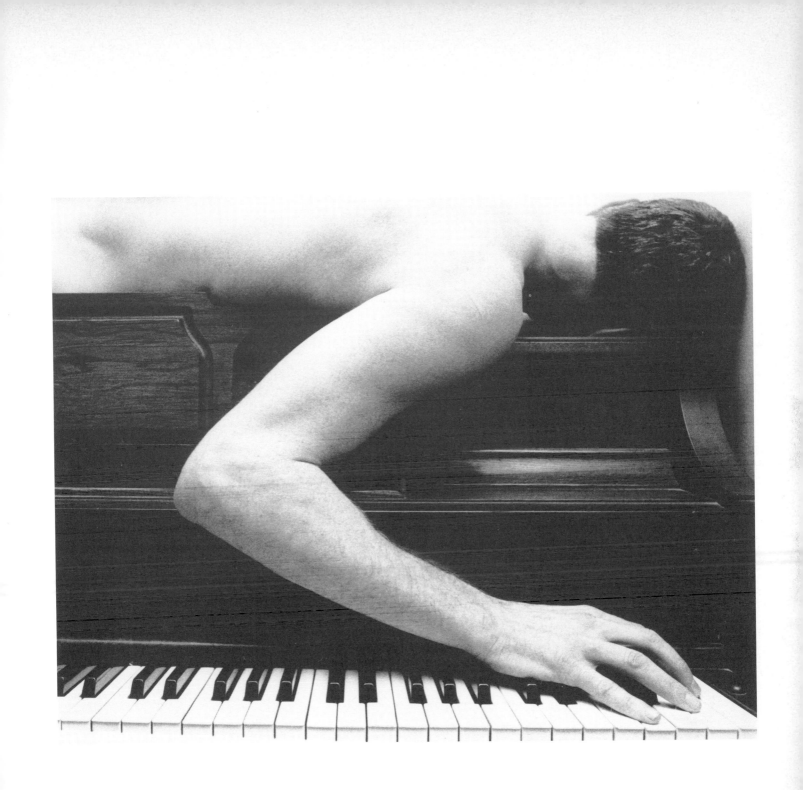

■ The Key Player

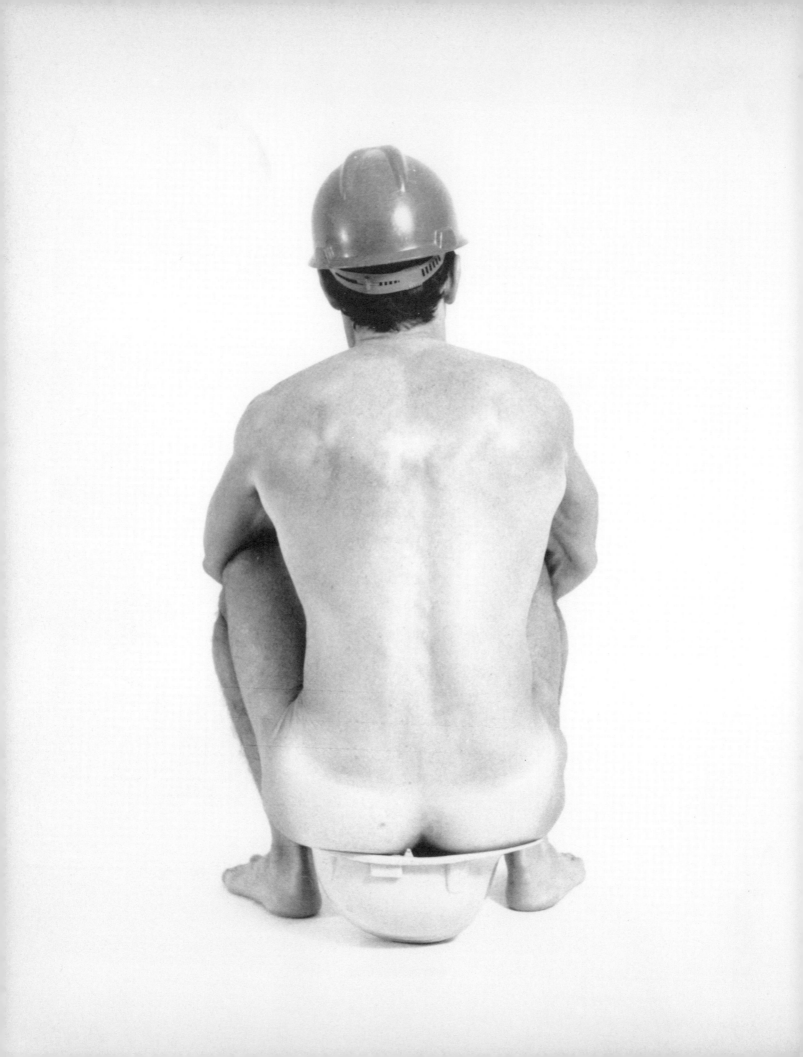

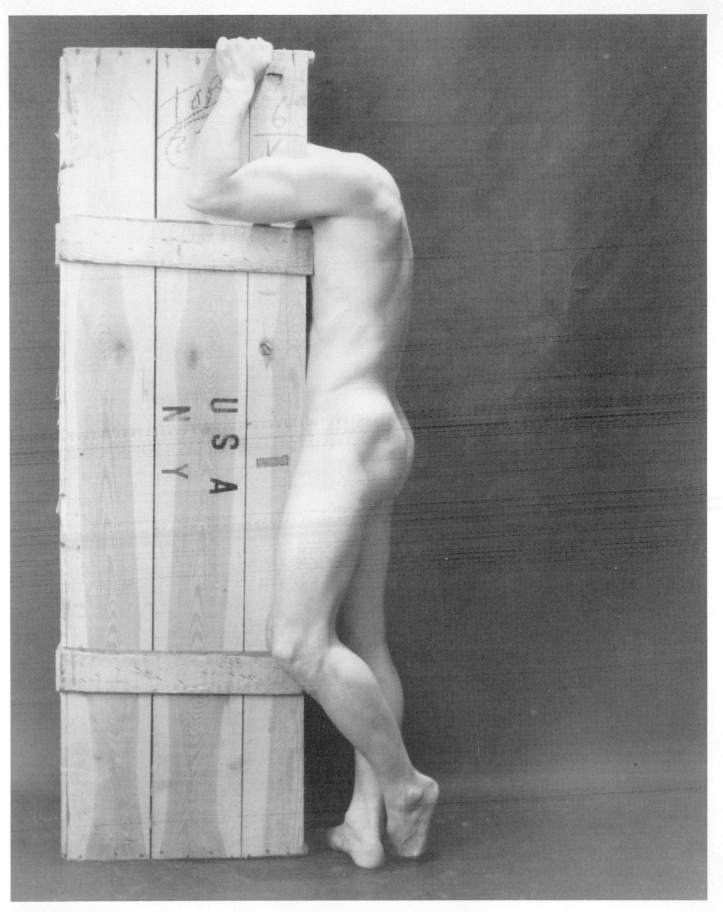

■ left: Site Unseen ■ . . . and he was crated in his own image

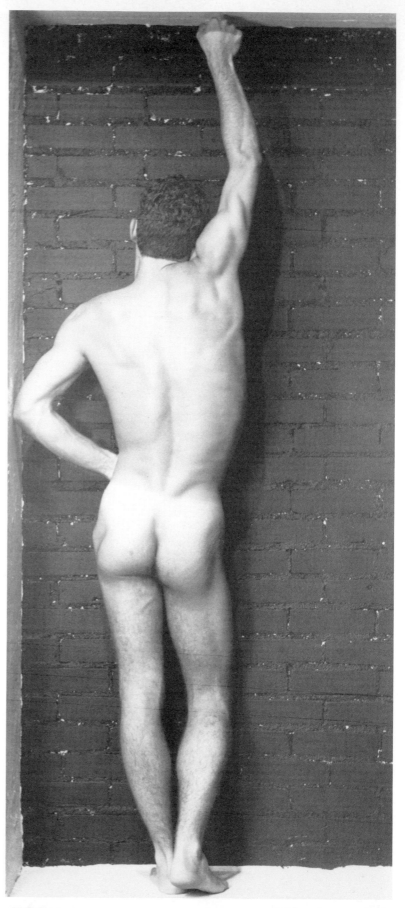

■ Doorway

■ right: Age of Youth

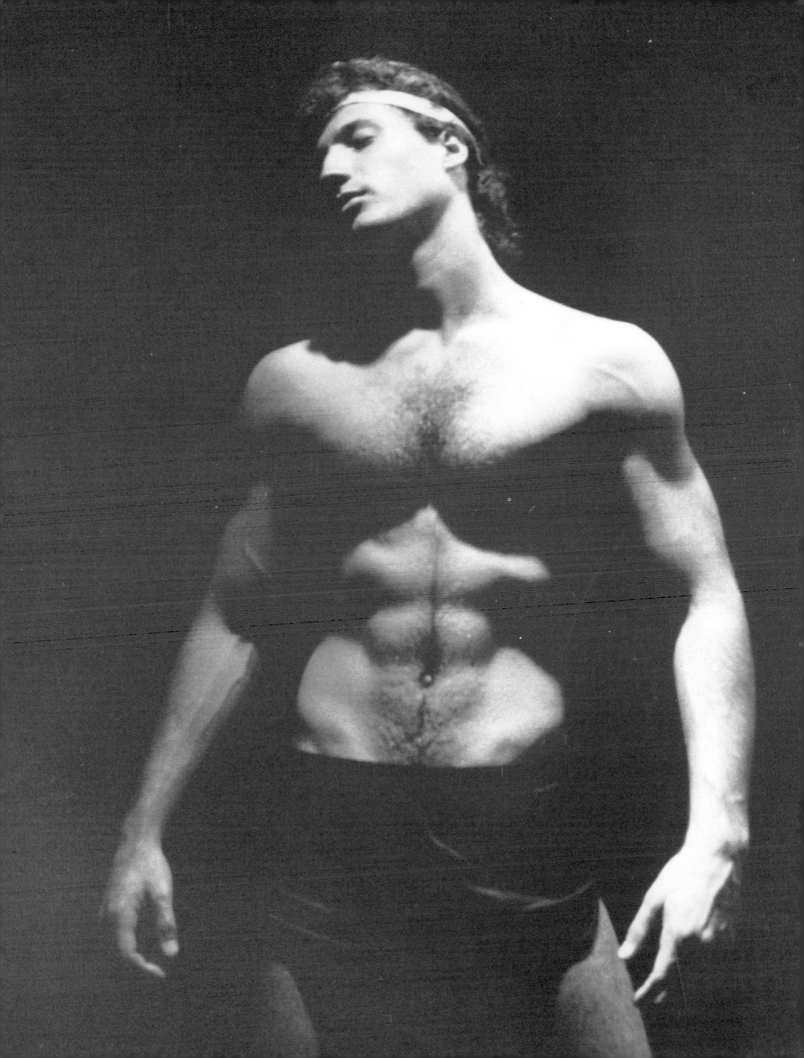

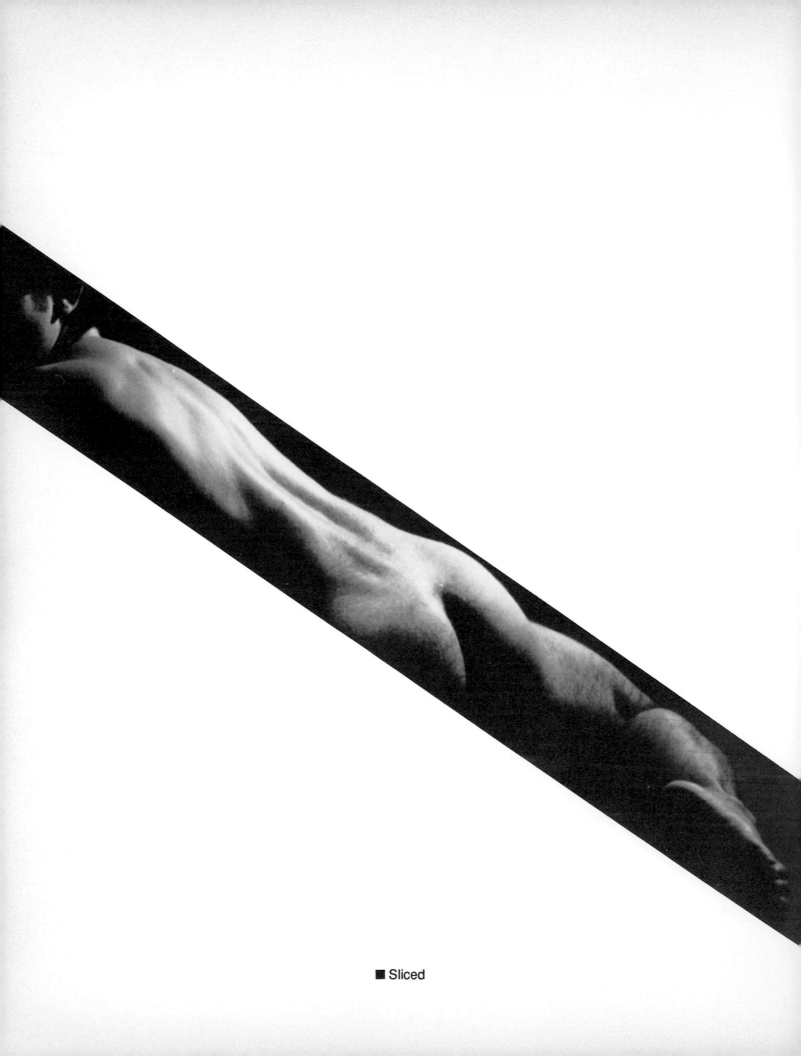

■ Sliced

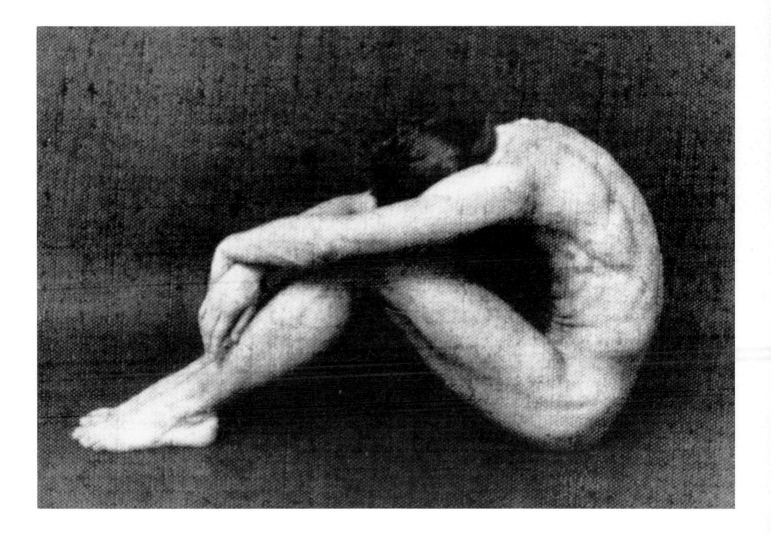

■ Dancer

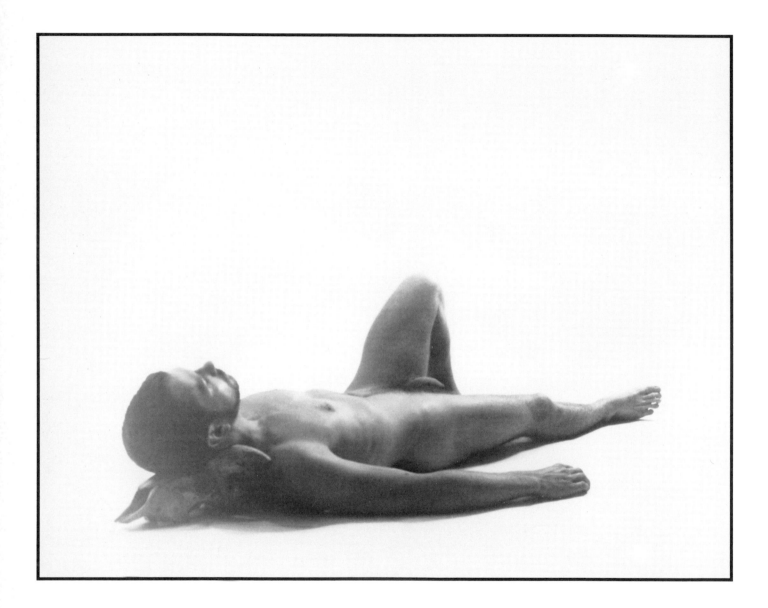

■ Thoughts on a Theme

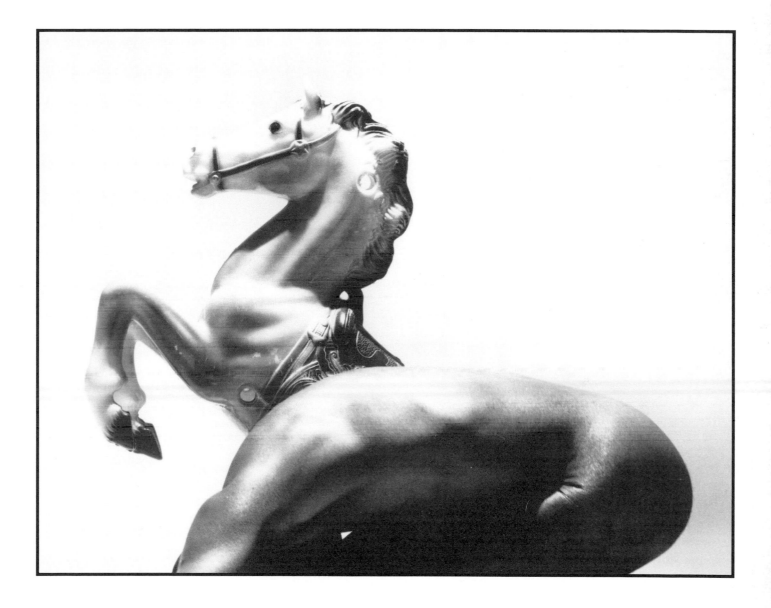

■ Knightmare

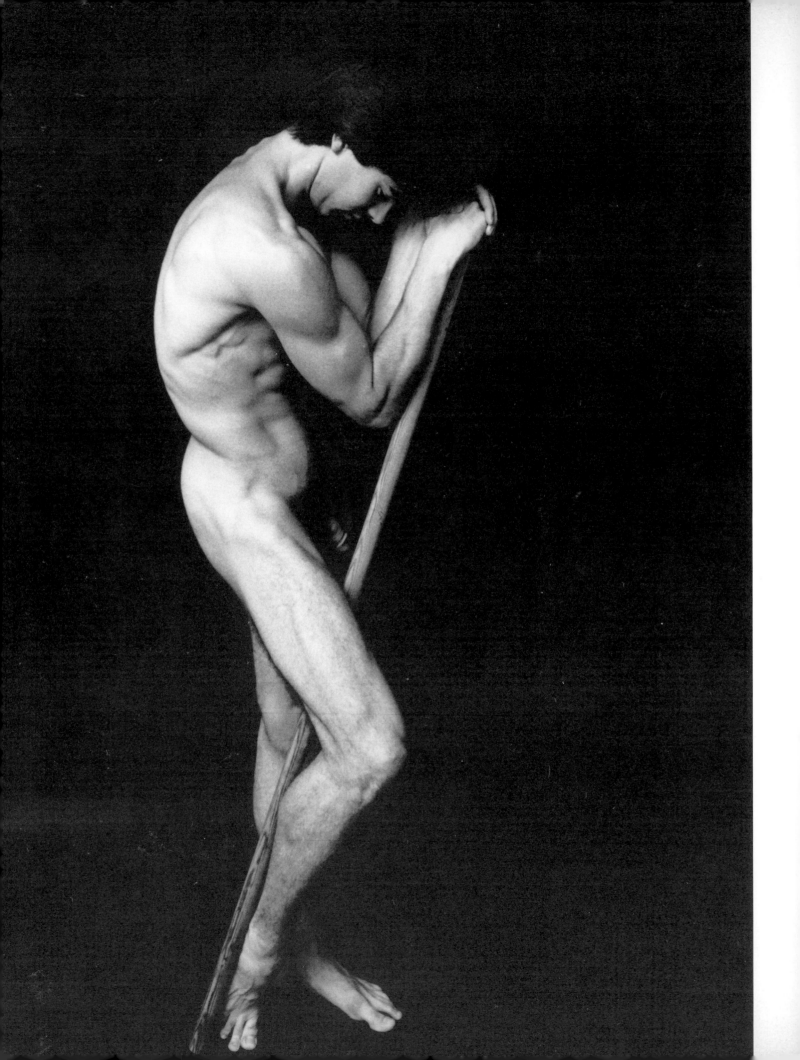

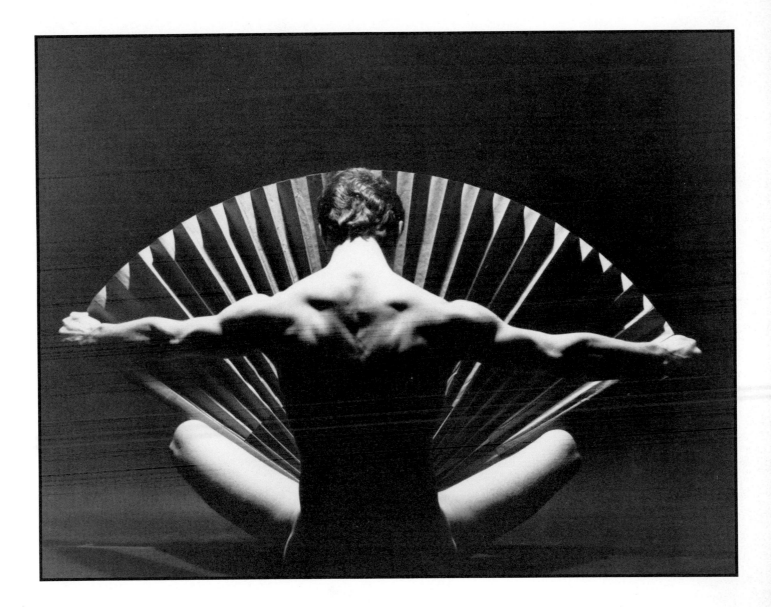

■ left: Man and Pole ■ Fan Male

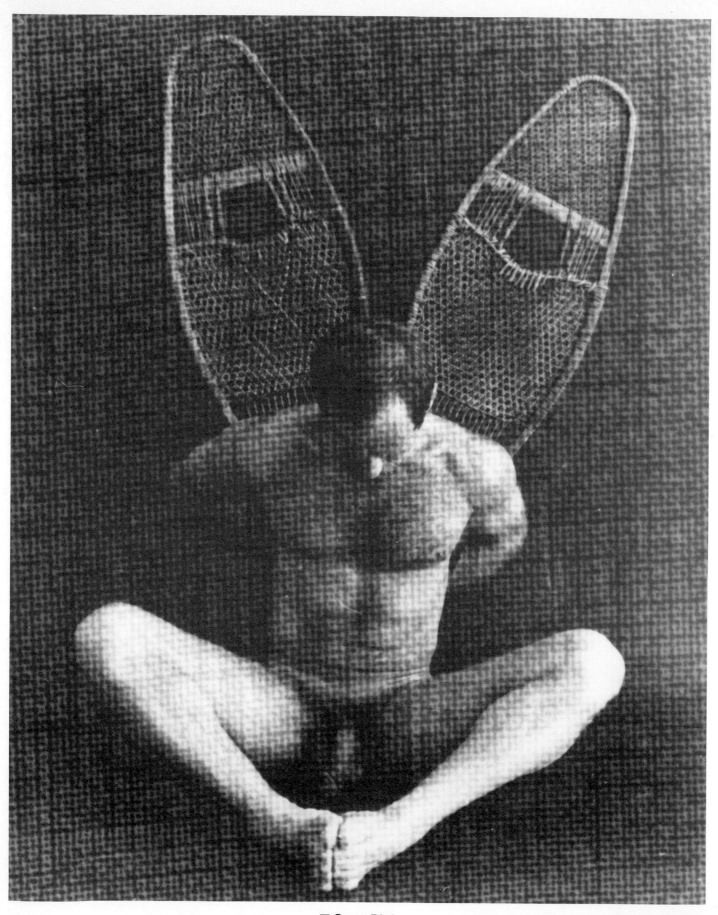

■ Snow Bird ■ right: Balloon

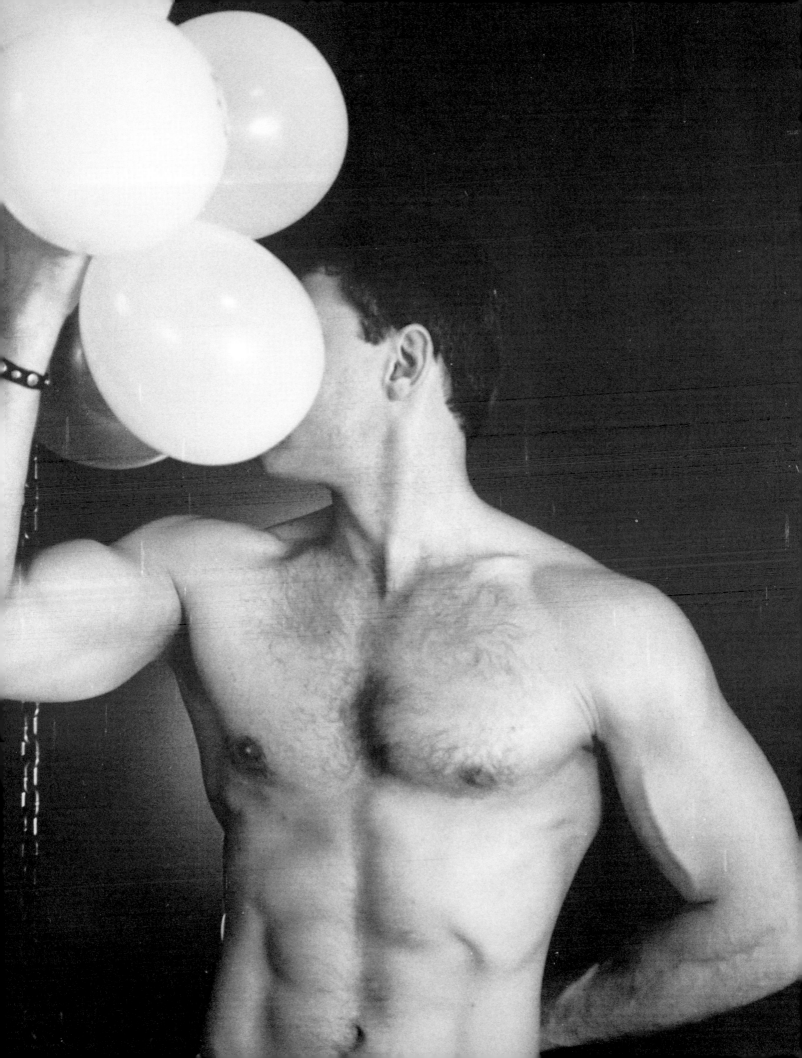

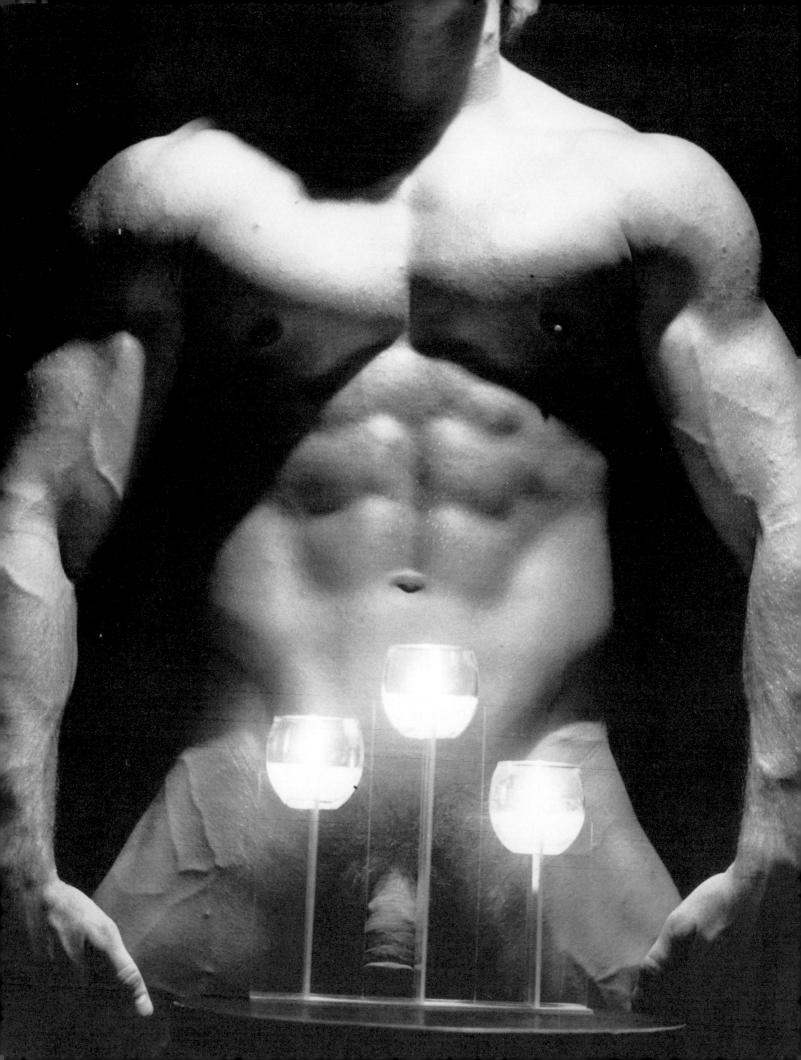

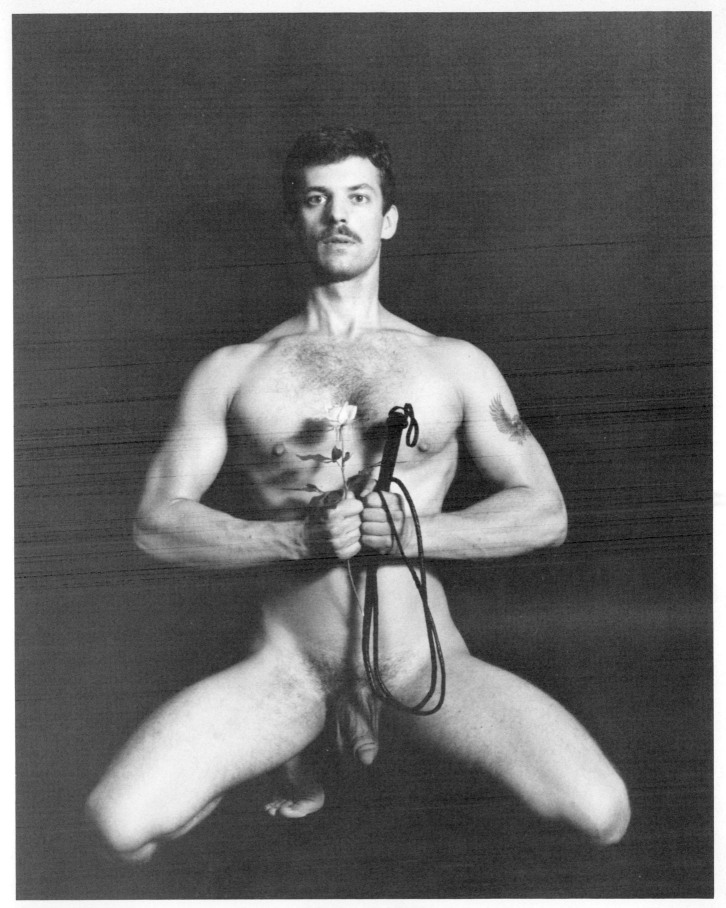

■ left: Candle Power ■ Tamer of the Bloom

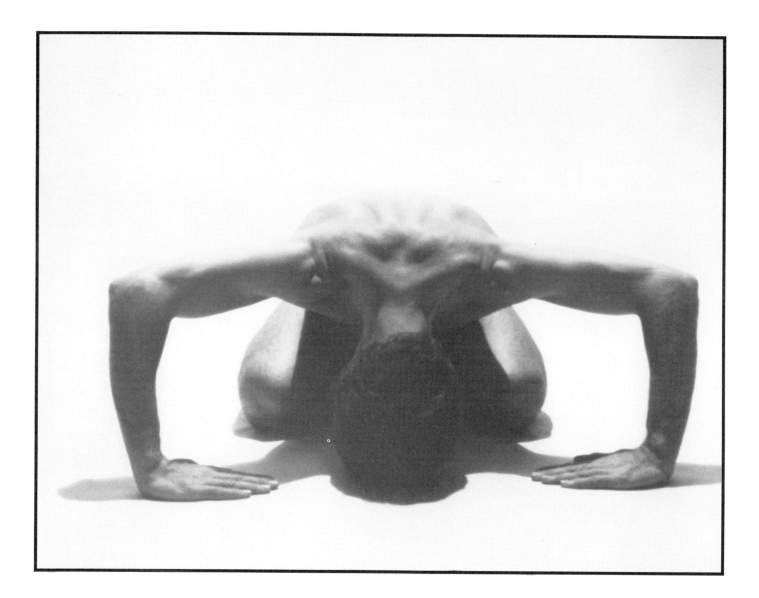

■ himage #19 ■ right: Klingsor

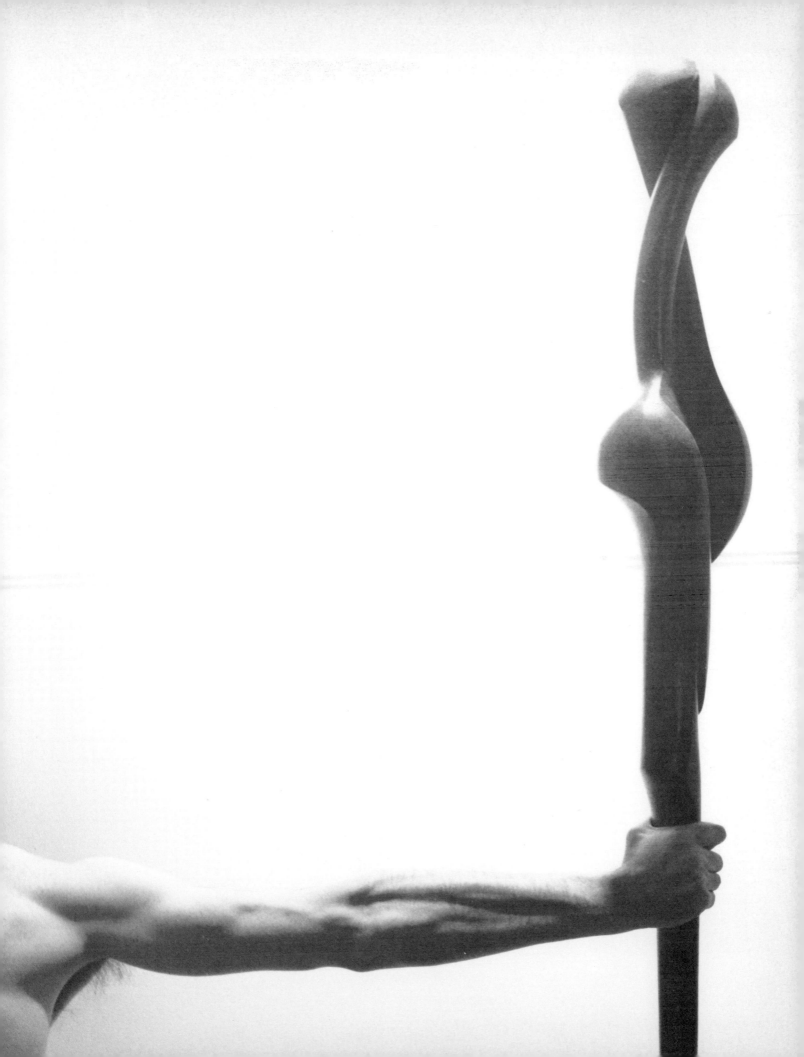

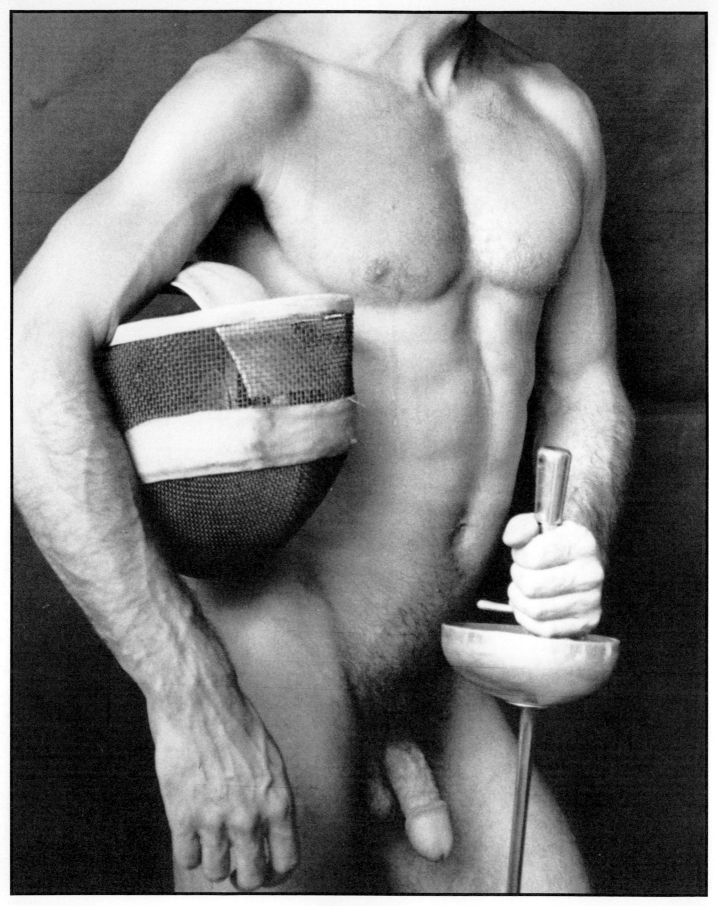

■ Swordsman

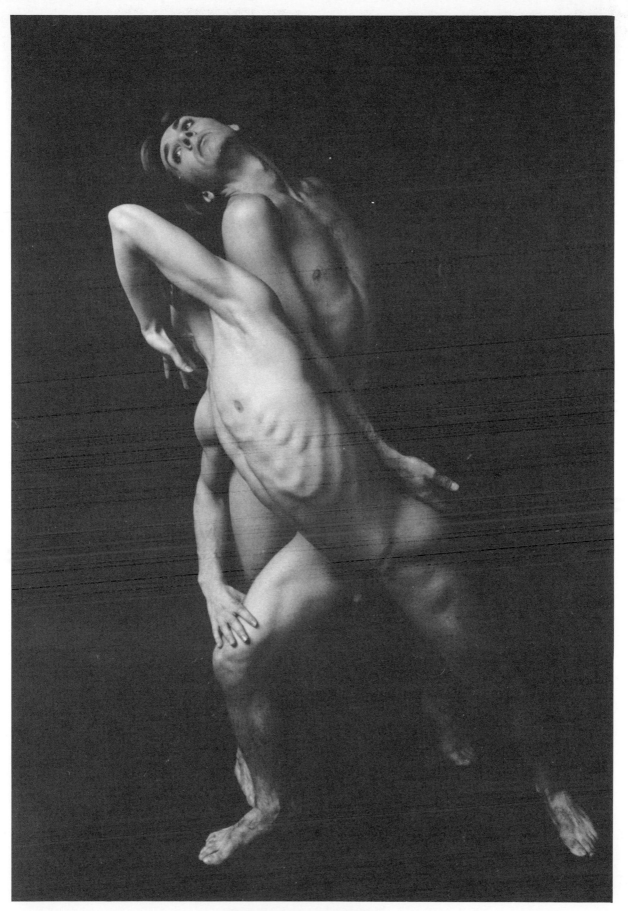

■ Dancers from the Dance

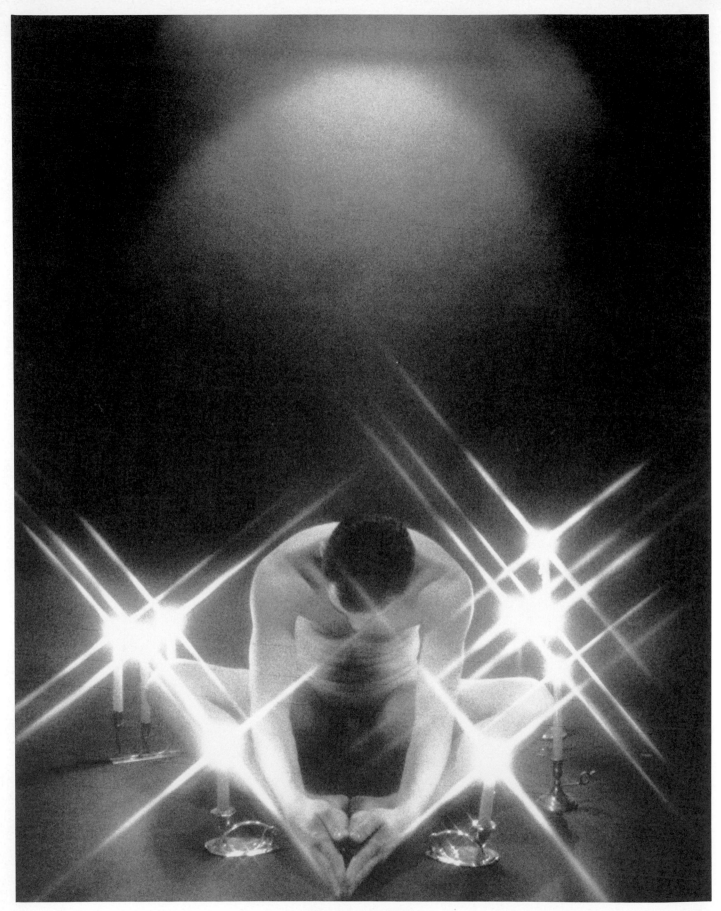

■ A Case in Point

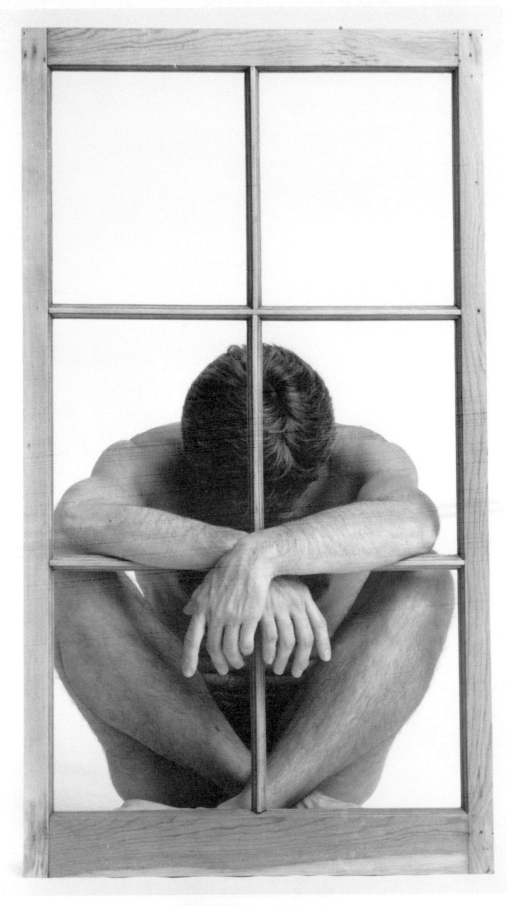

■ Himagery — Cantus 10

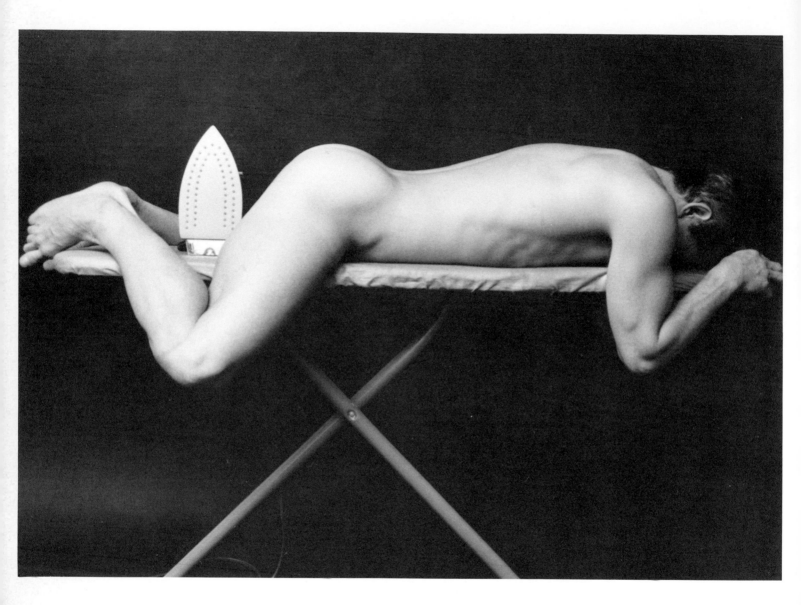

■ The Pressing Engagement

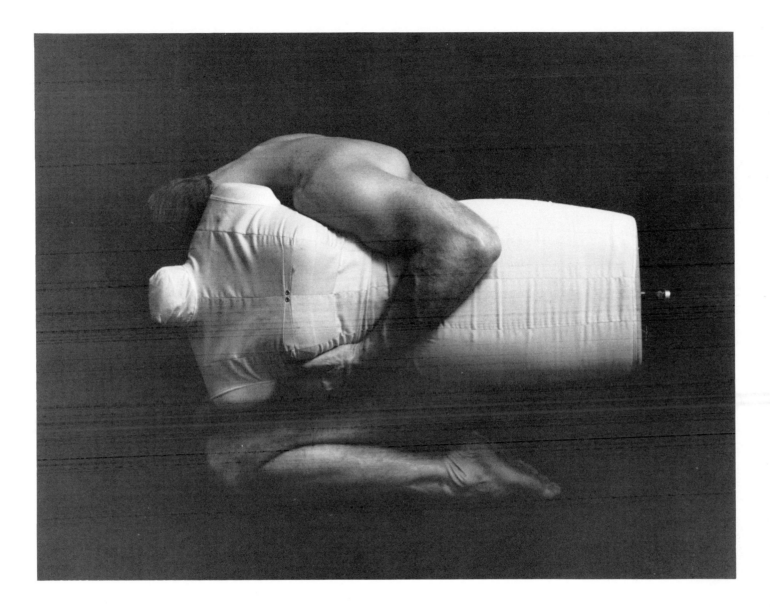

■ Bodyscape

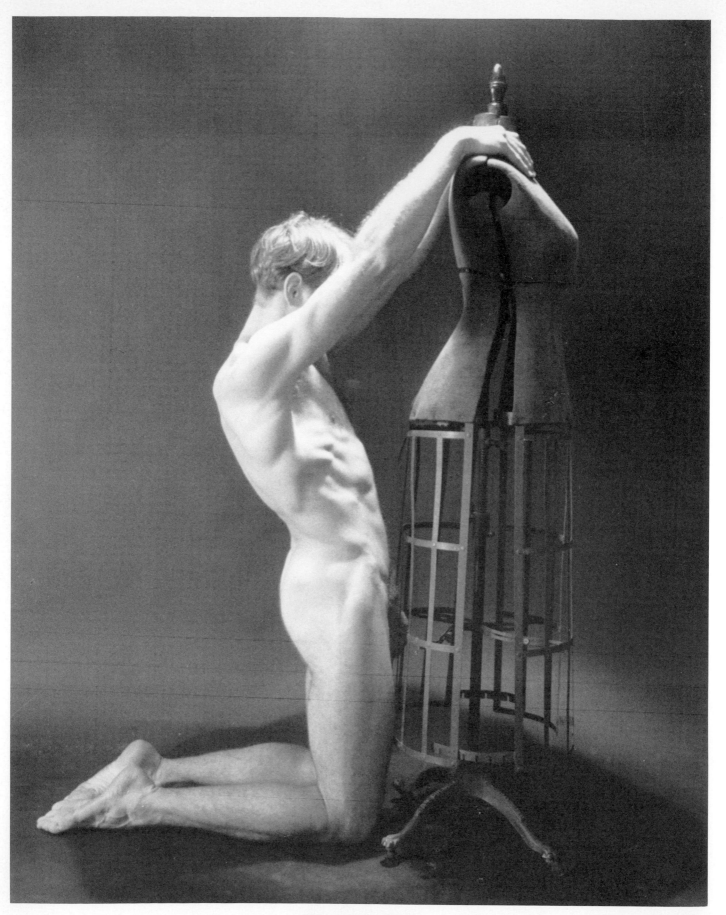

■ In Praise of Dolly ■ right: himage #2

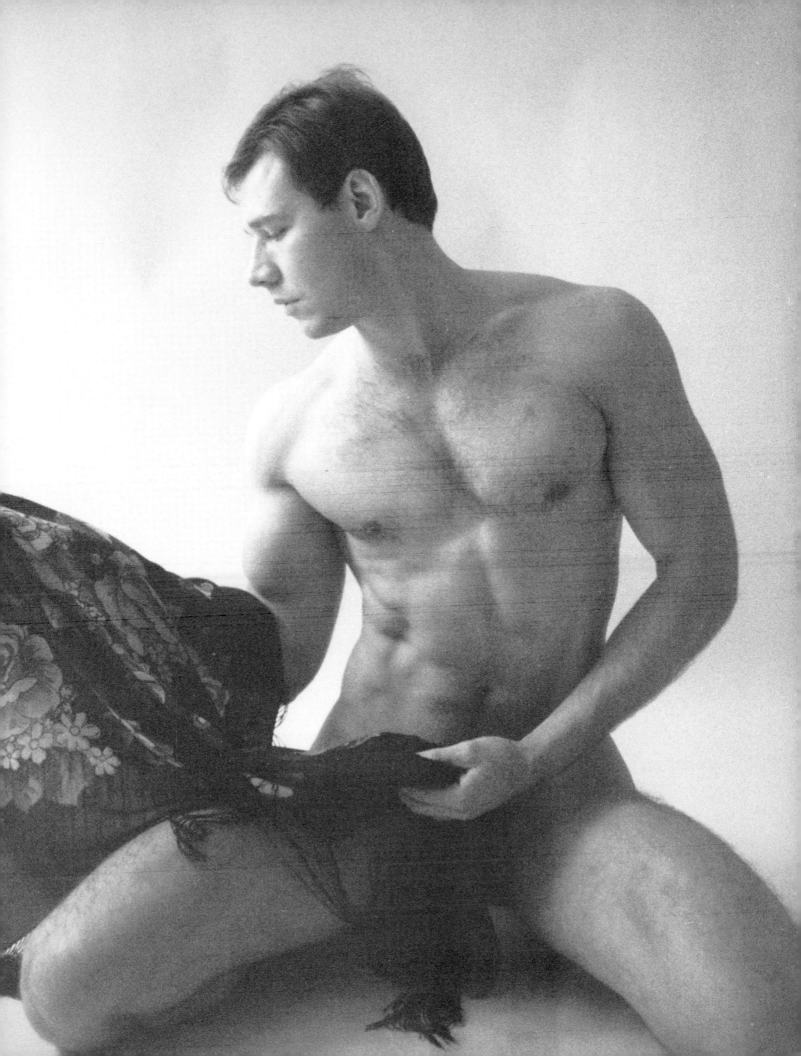

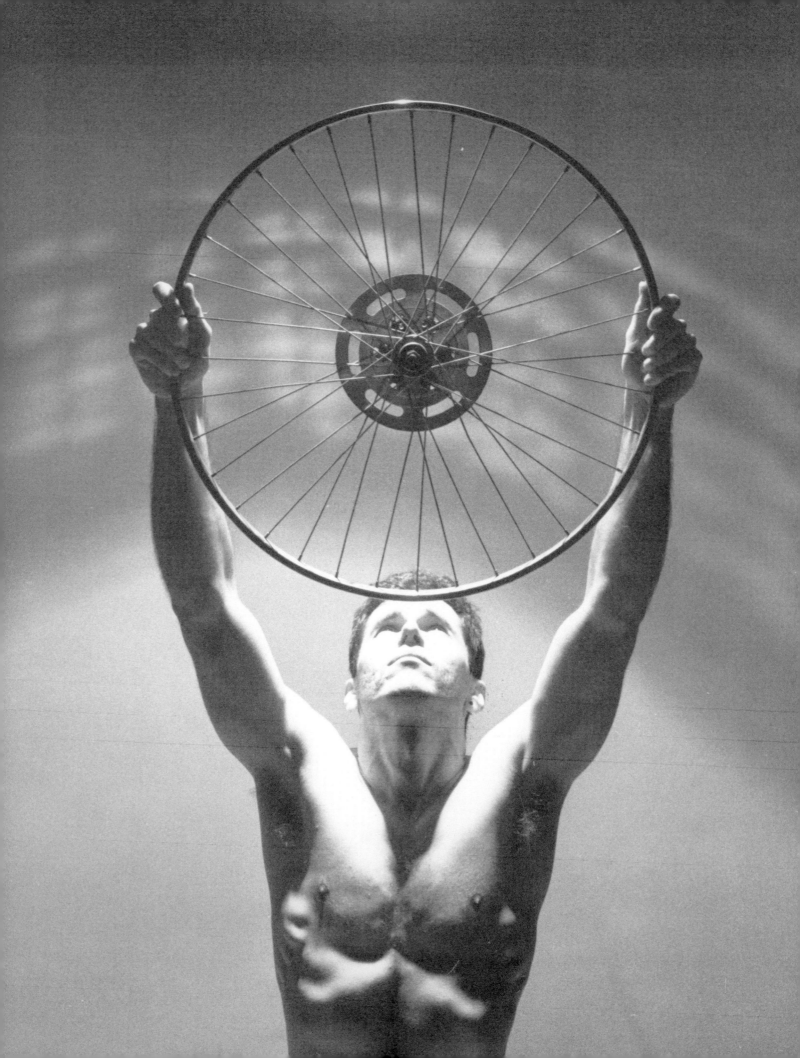

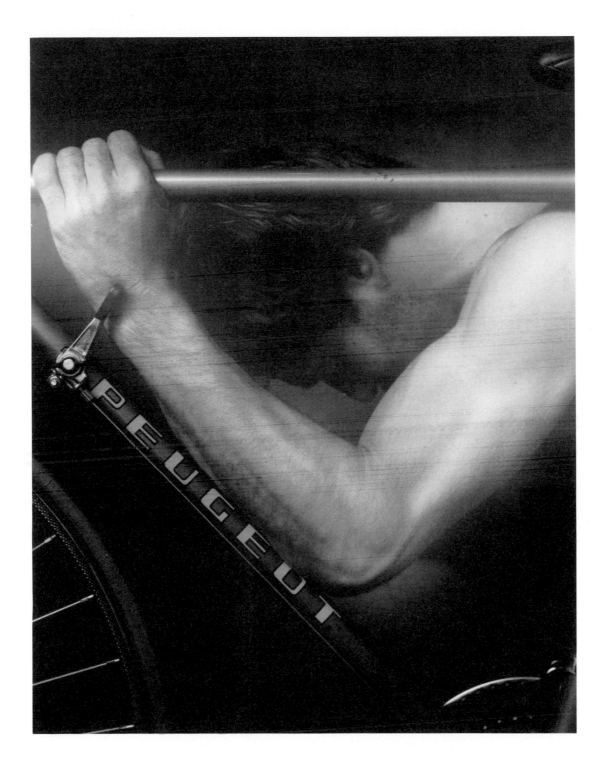

■ left: Son Cycle

■ Cyclist

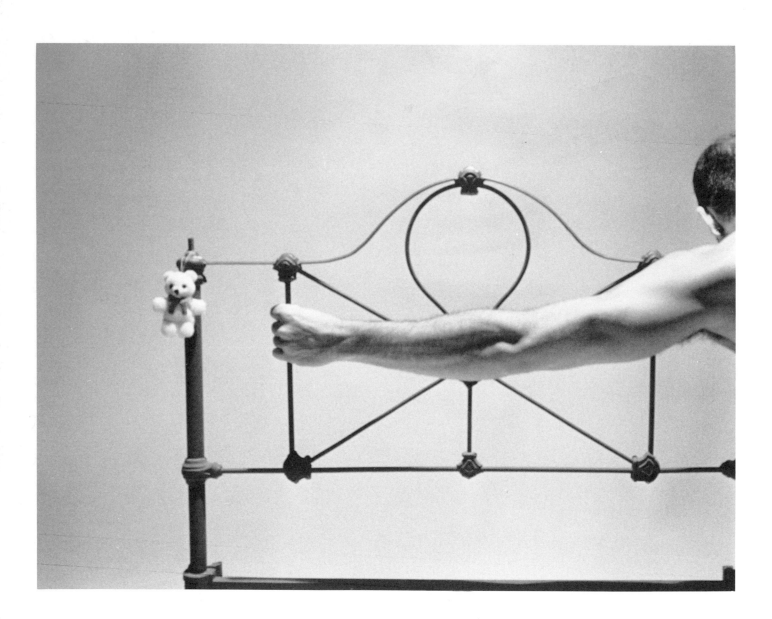

■ Bedtime Story

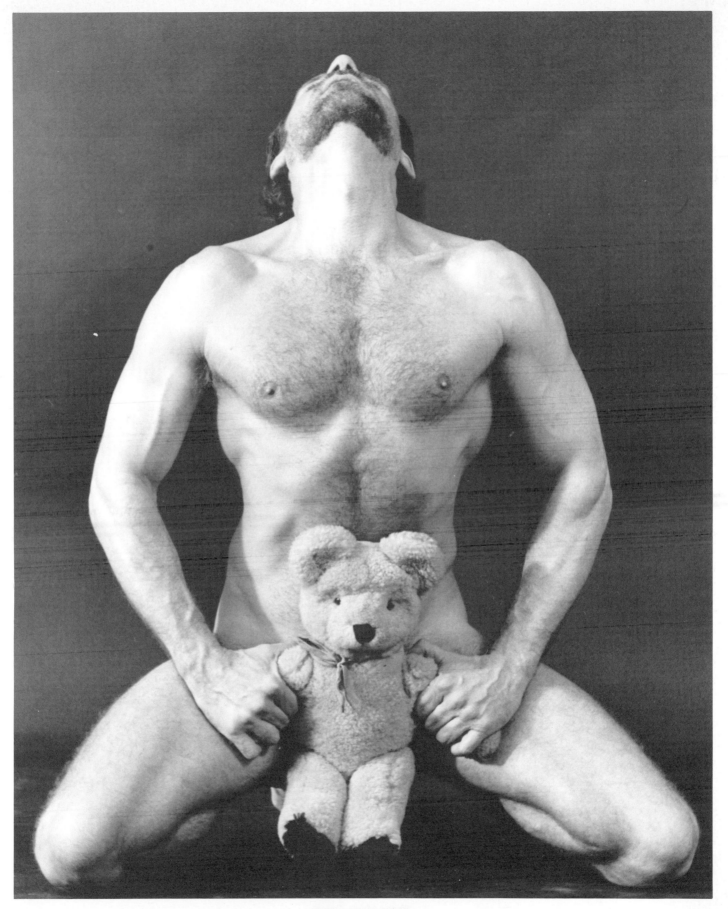

■ Bare Essentials

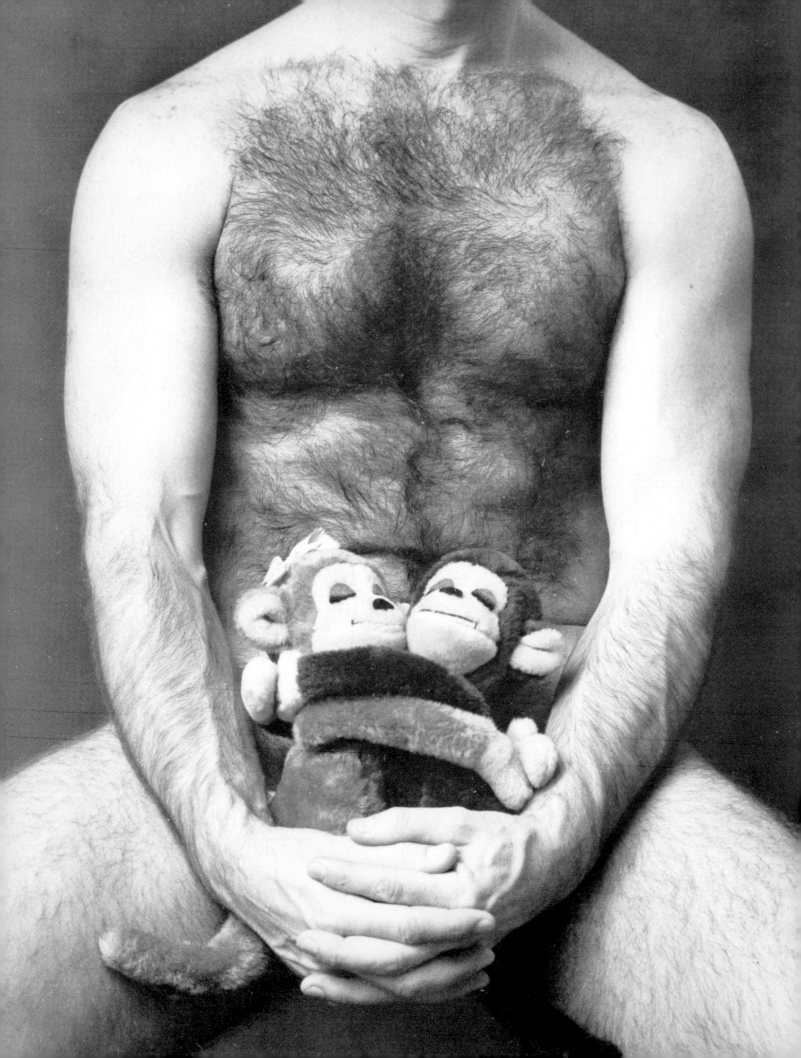

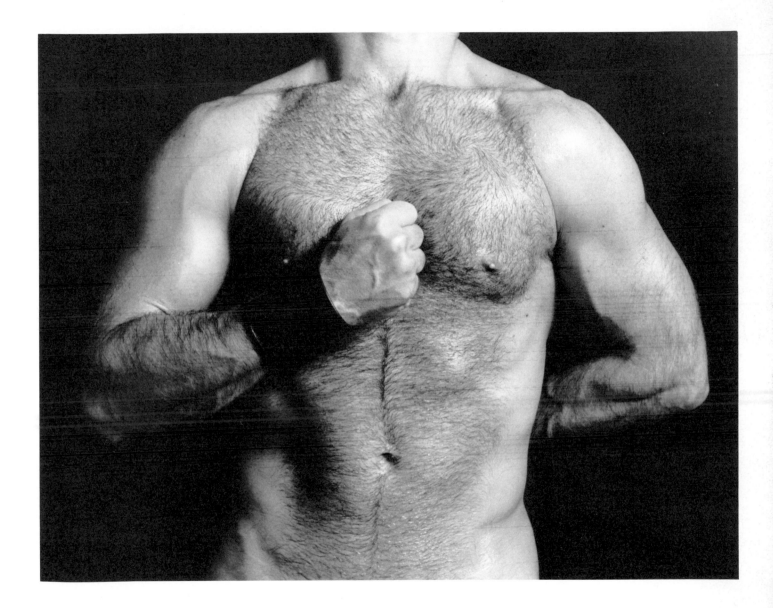

■ left: April Love

■ In Strength

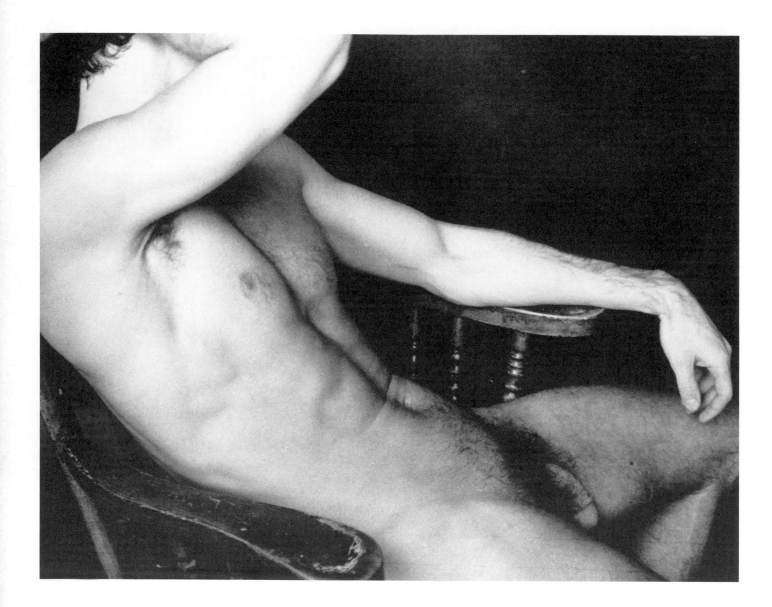

■ Of Light, Of Love ■ right: himage #4

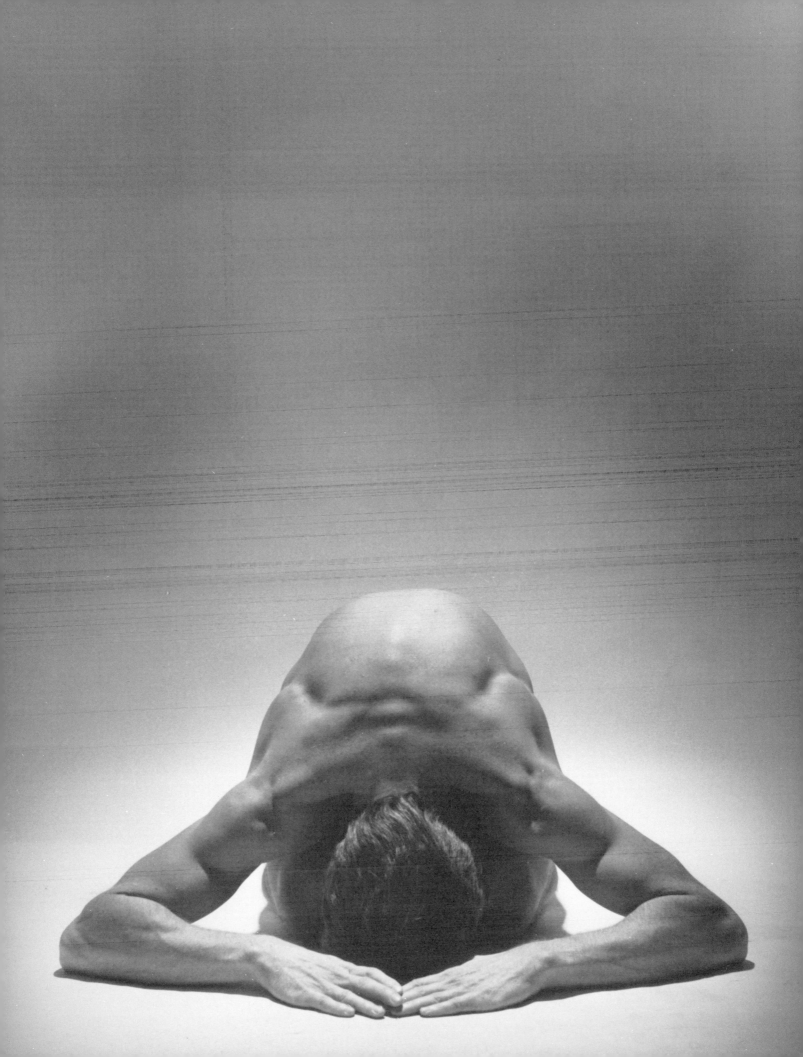

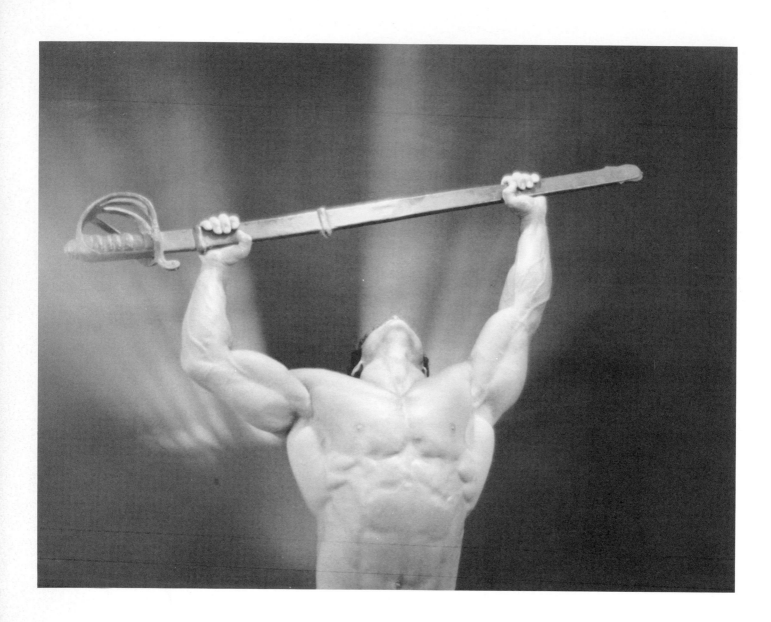

■ We Shall Conquer ■ right: Beauty and the Beast?

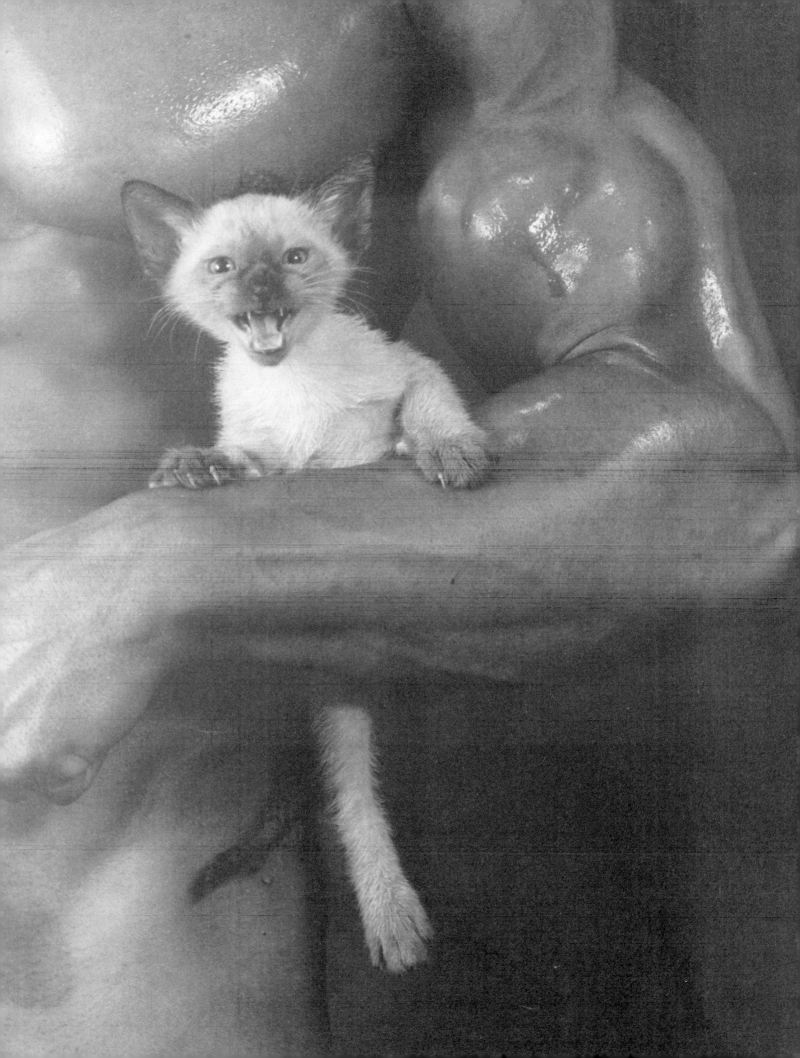

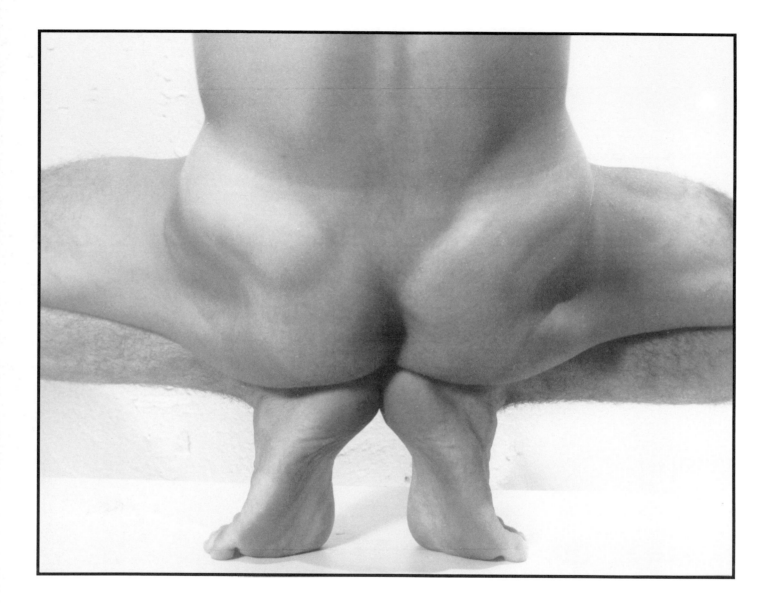

■ Form Kneeling

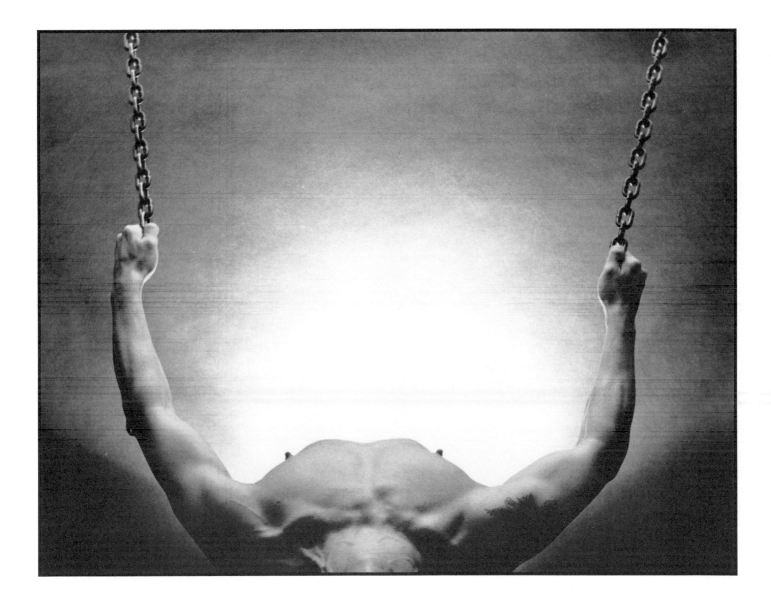

■ Chain Male

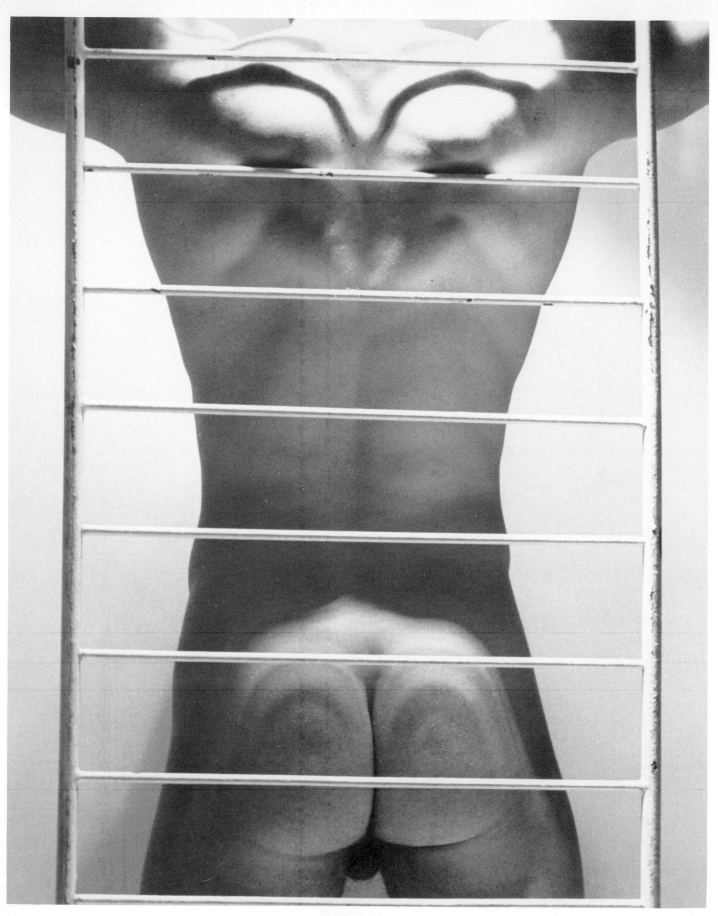

■ Bar None ■ right: Wagon

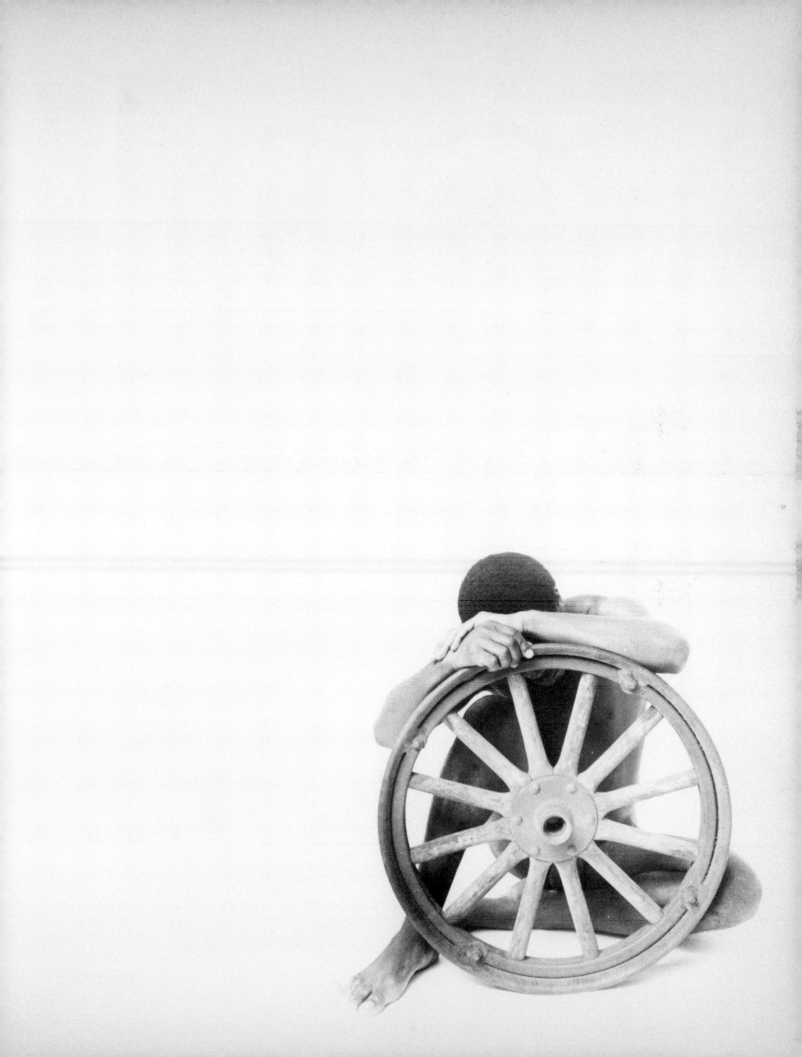

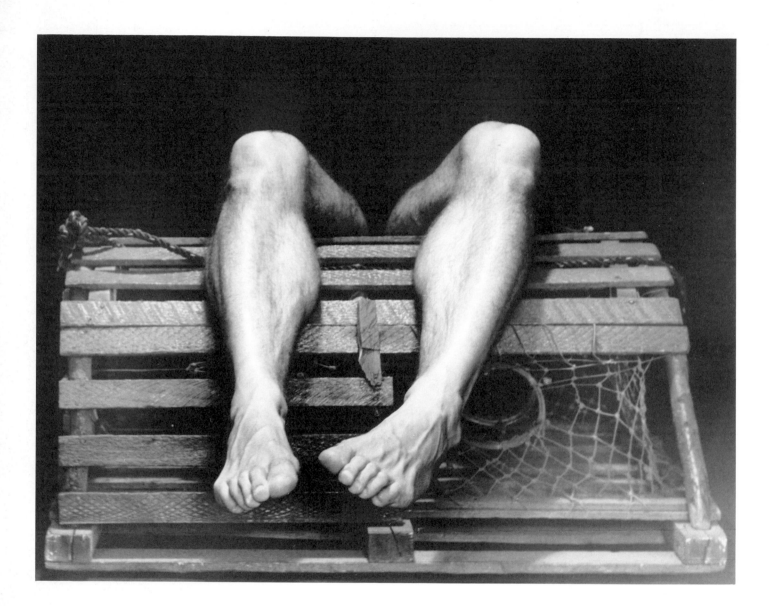

■ Undertow ■ right: Tread Softly

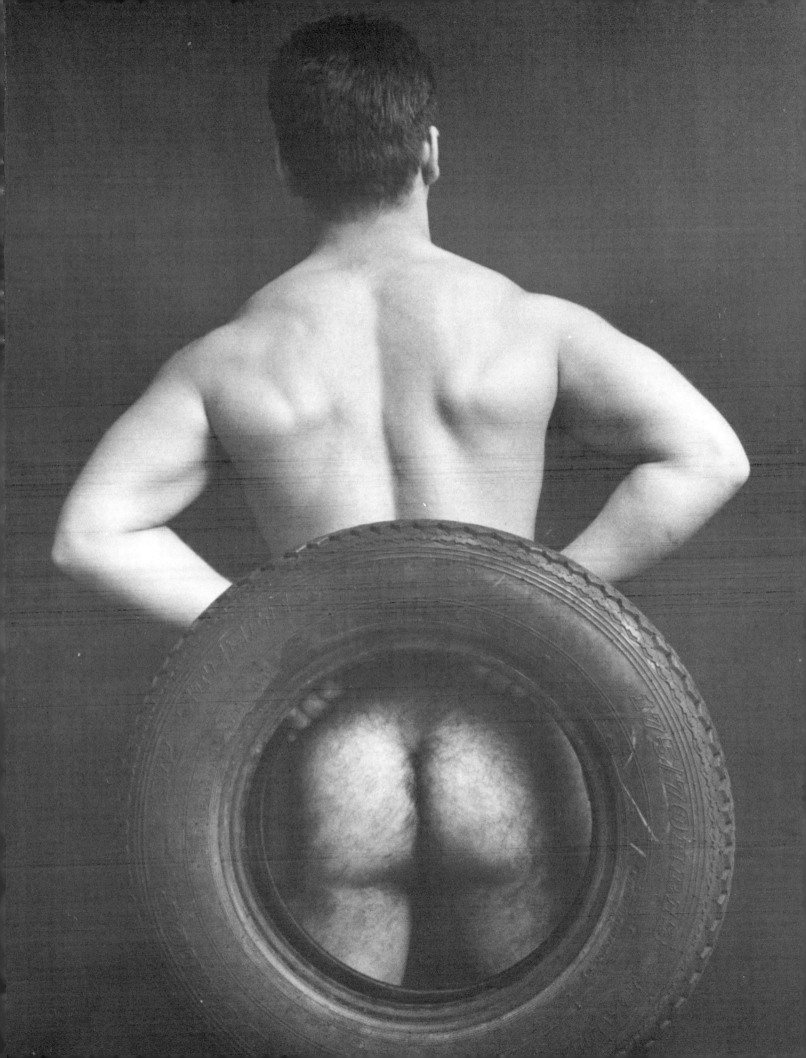

THE AUTHOR

Richard Plowright was born in Woolloomooloo, Australia. His work is included in the Canadian National Print Collection. In 1980 he was an award winner in the Professional Photographers of America Annual Exhibition, and he has twice won awards from the Professional Photographers of Canada National Exhibitions. He is a photographic judge and a regular contributor to many photography magazines, and is the owner of the modeling agency Muscle To Go.

Information about the sale of prints may be addressed to Richard Plowright, Box 6245, Toronto Delivery Centre "A", 25 The Explanade, Toronto, Ontario, Canada, M5W 1A0.